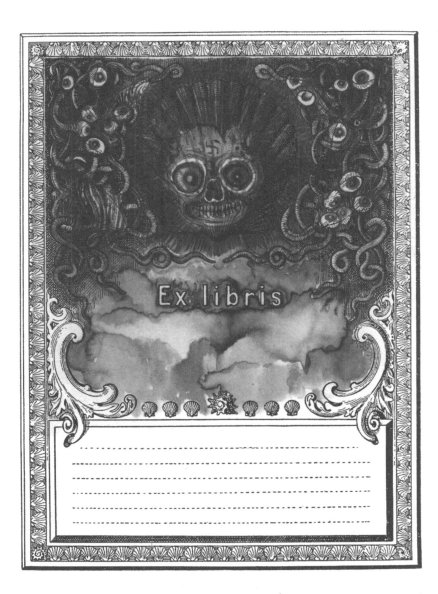

Bedtime Tales
*for*
Sleepless Nights

Jake & Dinos Chapman

FUEL

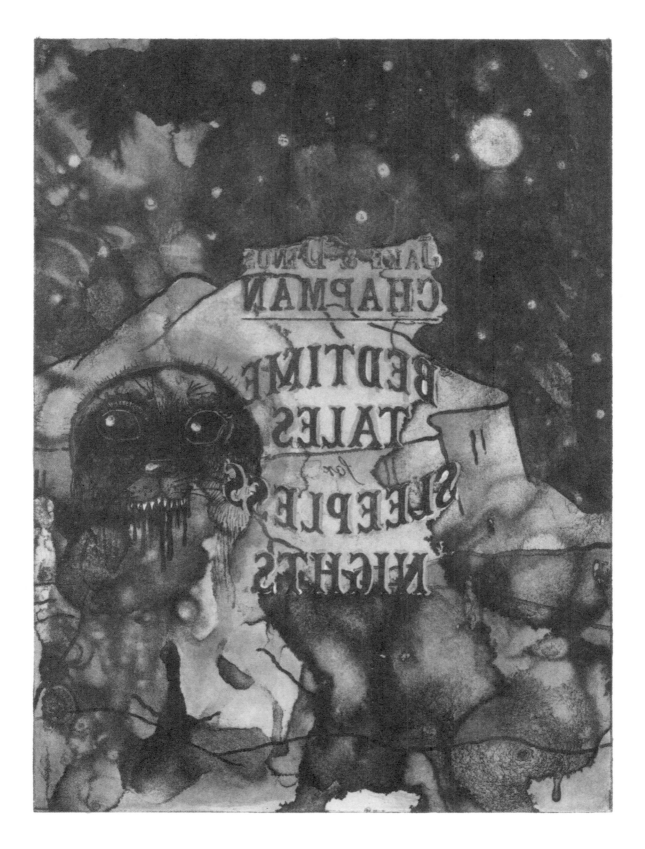

Sticks and stones

Shall break thy bones

And words will

Surely hurt you

Eyeballs and teeth

Shall be wrenched by grief

As nightfall comes

To shroud you

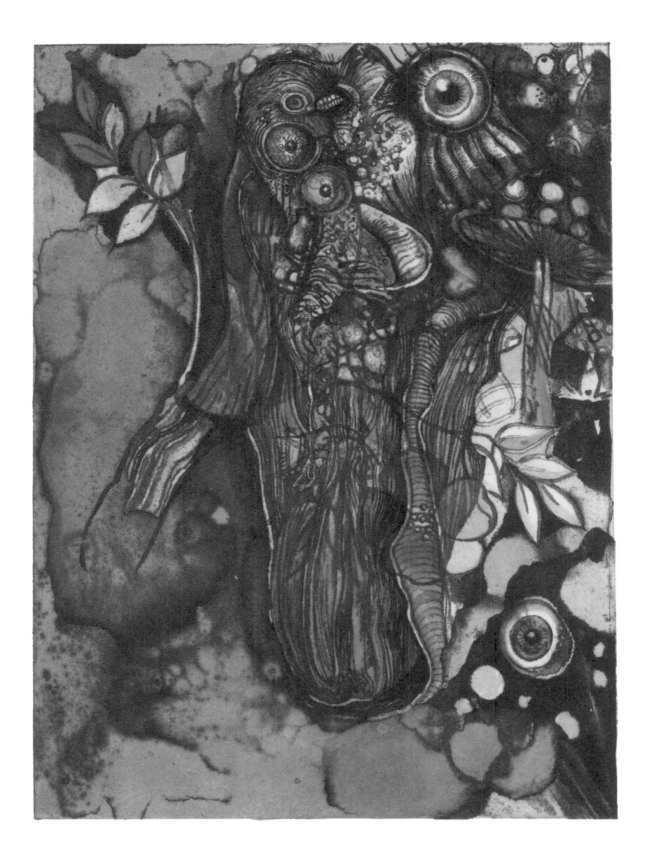

No kindly smile

Nor elegant grace

Can prevent the worms

From gnawing at your face

For *night* is galloping

On trusty *mare*

Hell-bent on seeking

Little-ones to scare

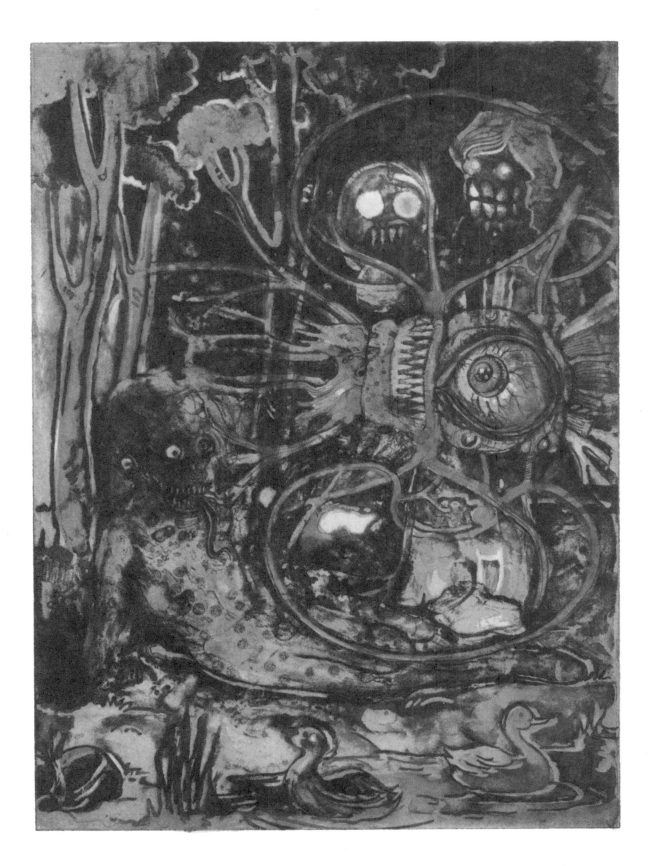

Teeth shall chatter

A sour rictus grin

To strip this countenance

And pare its skin

From forehead to nose

Peeled right down to chin

A brand new sneer

For a brand new sin

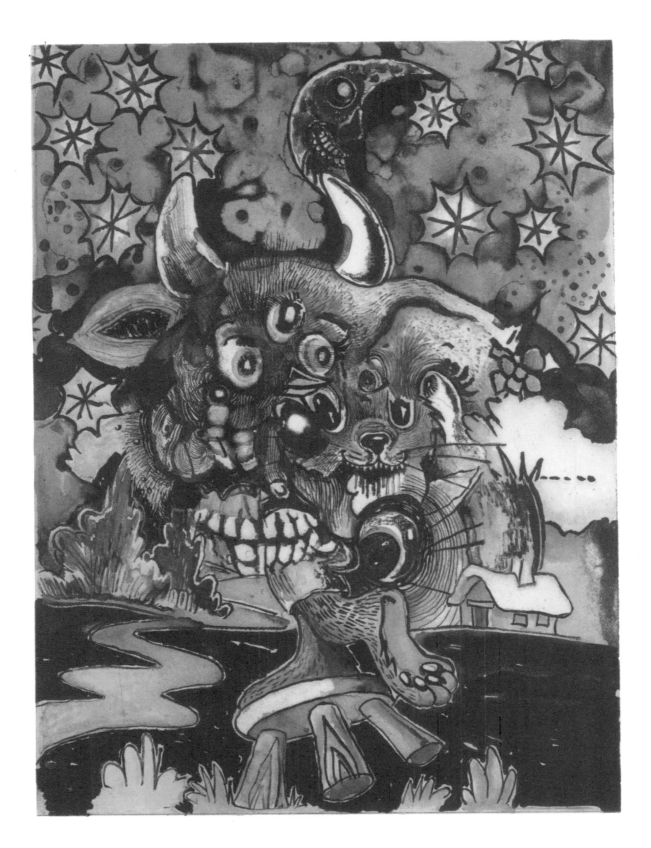

Of skin and bone

So cruelly flayed

And blood in fresh air

Tarnished and betrayed

A bare-faced skull

In brazen glory

Murder unmasked

Unrepentant and gory

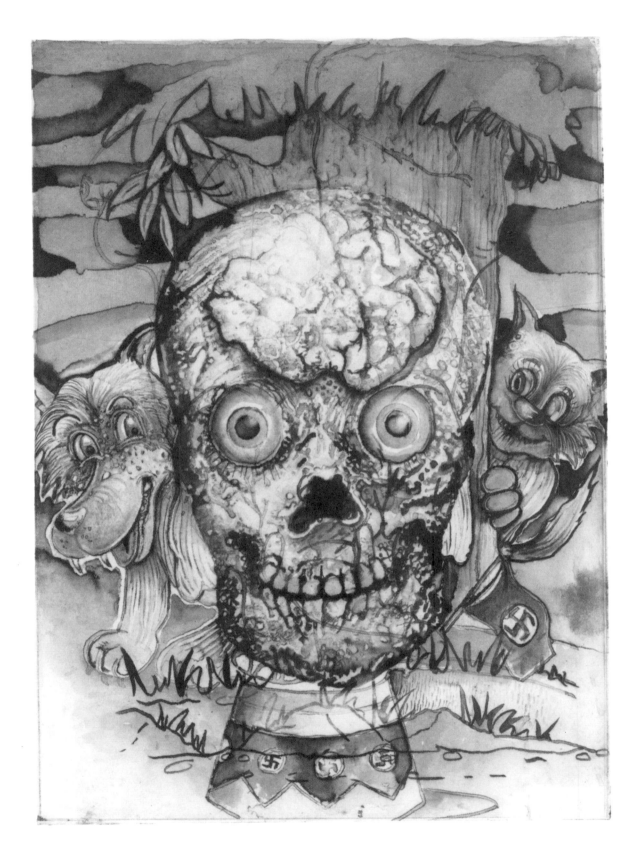

Crooked ivories
Mock with pure mirth
To scorn the error
Of your untimely birth
(and dare I mention
that your Mummy's pain
was only anyway
suffered in vain)

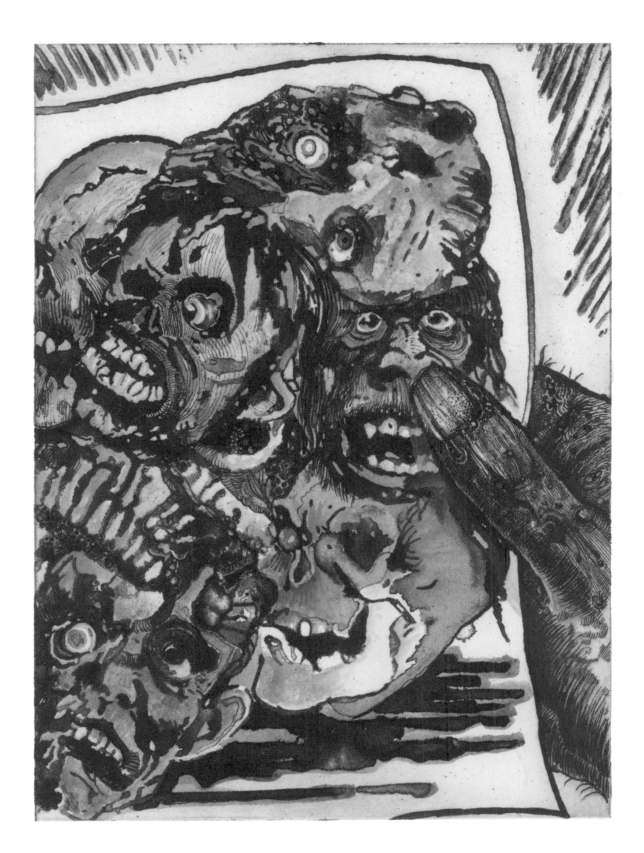

This hideous armature

That hides and seeks

Will outlast the flesh

Its turn to reek

Hung out for death

On spiny barb

Your birthday suit

Now an ill-fitting garb

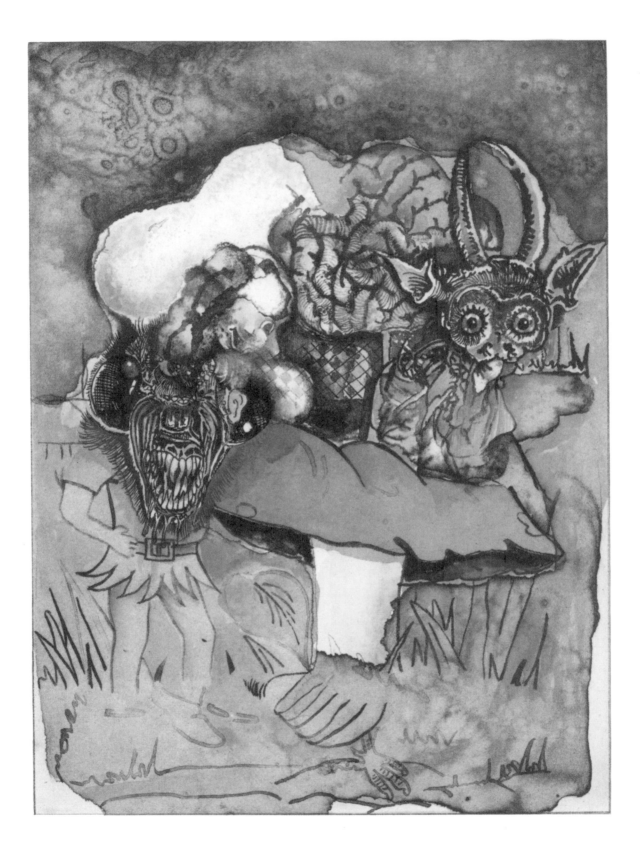

And deep inside
The cranial core

Insects of the mind
Drill and bore

The creeping crawlies
That nibble and mutter

With mandible jaws
And wings that flutter

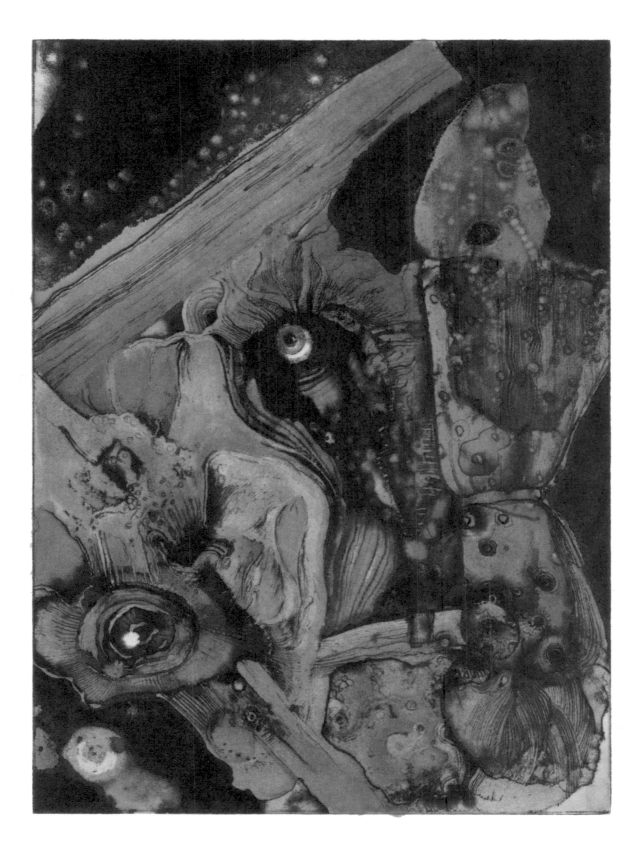

So prop your lids
With cocktail sticks

Prepare to weep
For the onslaught of sleep
The only companion
In this chamber of gloom
Is the anaemic wash
Of a demented moon

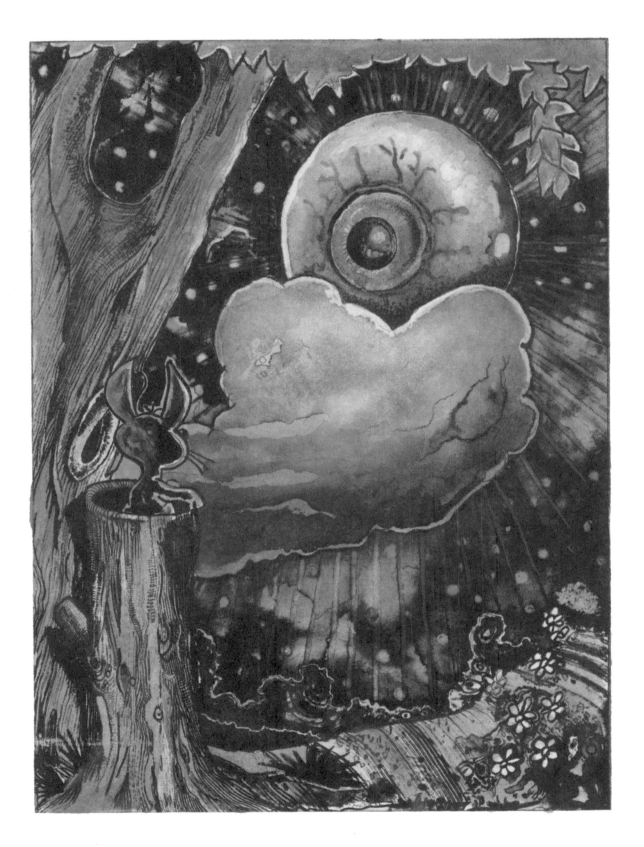

As a simple lamb

Innocently bleats

A knotted rope has

A suicide to complete

To sleep or dream

Now an impossible feat

Only the appetite for

Torment to greet

— Ah! Here they come!

*The pitter-patter of broken feet!*

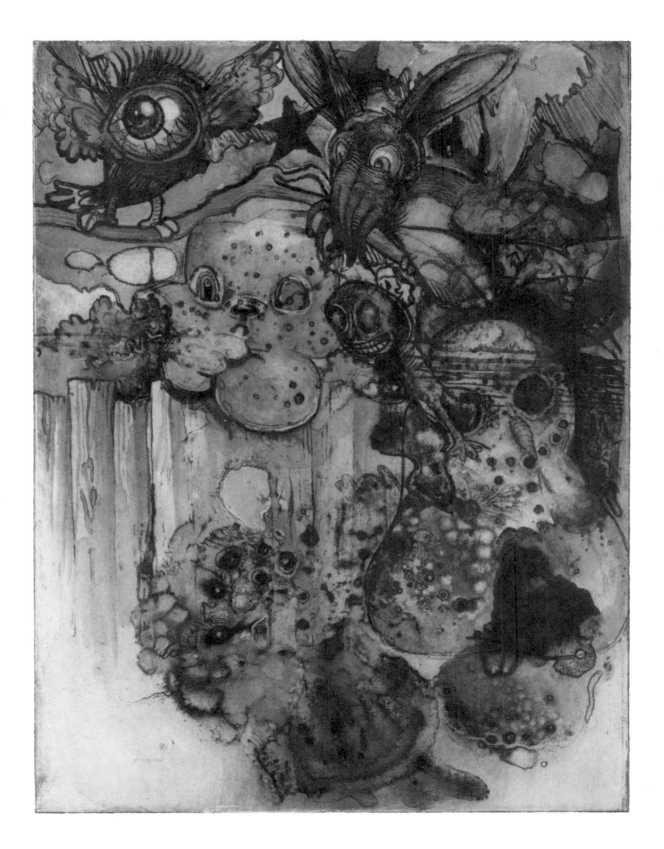

Malice shall come
To wreck the night
To cleave its comfort
And impugn your delight
The fear of *the unknown*
And *the you know what*
To the apoptosis of the soul
Add a malignant clot

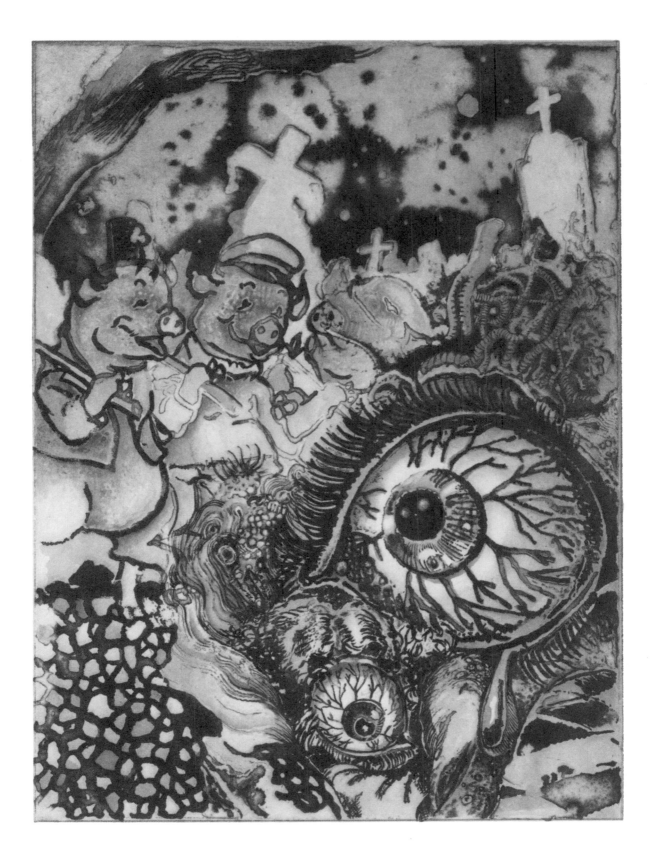

Like a dirty tide
Sullies a pretty beach
A bedtime prayer
Grates the ears it entreats
But the voice of an angel
Now butchered and shrill
Begs for forgiveness
And pleads for *goodwill*?

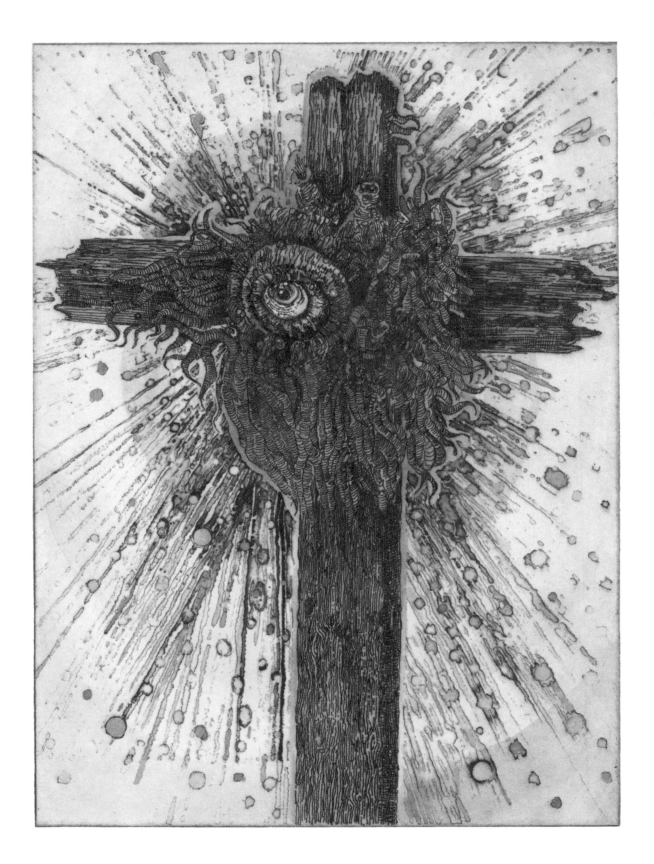

*Oh lord have mercy!*

Croaks its wizened craw

Profanity implores

Yet again – and once more

Thus it pleads

In the dead of night

To banish insomnia

For the sake of a *goodnight!*

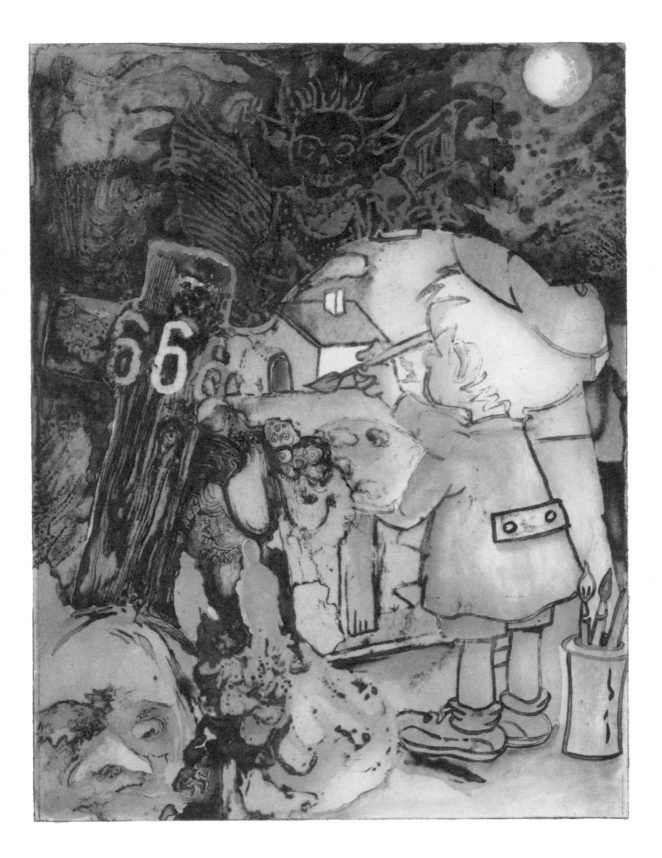

But this heart rages
With fossilized fright
That its arterial flow
Just actually might
A clot congeal
In pulsating trap
This dead muscle
Has pumped its last lap

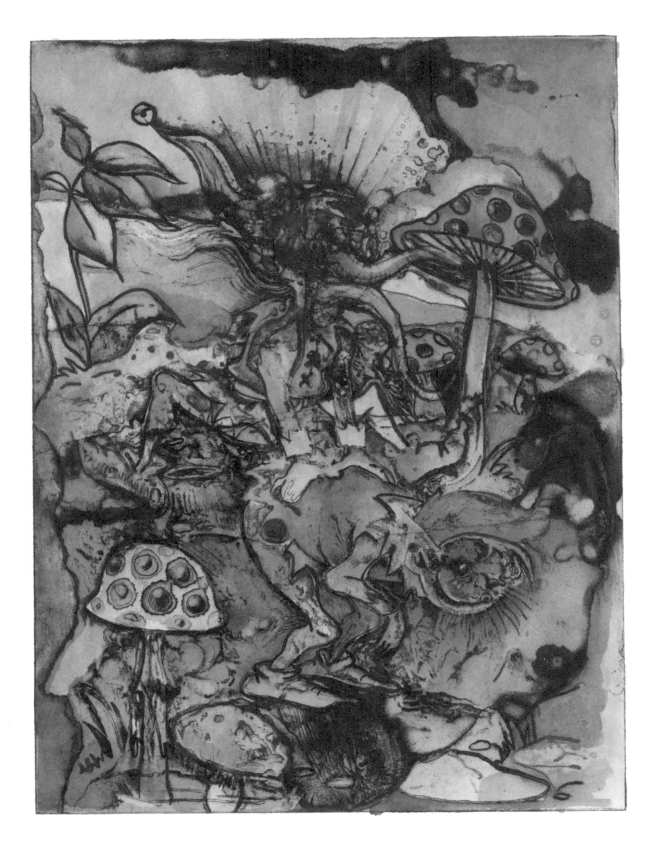

But remember little ones —

The unconscious has its horrors
But they are not anthropomorphic
It is not the sleep of reason which
Engenders monsters but vigilant
And insomniac rationality*

*Deleuze and Guattari

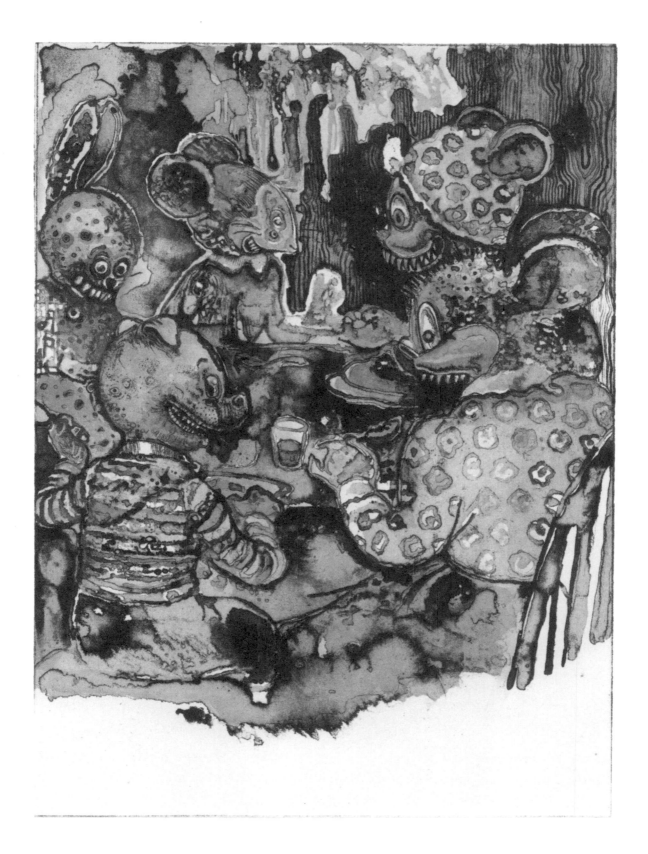

First published in 2012

FUEL©
Design & Publishing
33 Fournier Street
London E1 6QE

fuel-design.com

Designed by Murray & Sorrell FUEL
Printed in China

Distributed by Thames & Hudson / D.A.P.
ISBN 978-0-9558620-9-0